I WANT TO DRAW™

DINOSAURS

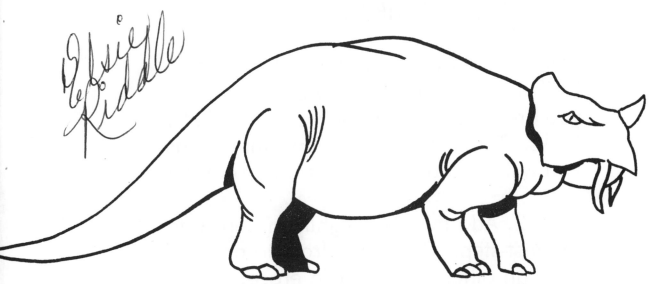

WRITTEN AND ILLUSTRATED BY ANTHONY J. TALLARICO

Copyright © 1993 Anthony J. Tallarico
Copyright © 1993 Modern Publishing, a division of Unisystems, Inc.

® Honey Bear Books is a trademark owned by Honey Bear Productions, Inc.
and is registered in the U.S. Patent and Trademark Office.

™ I Want To Draw is a trademark owned by
Modern Publishing, a division of Unisystems, Inc.

Modern Publishing
A Division of Unisystems, Inc.
New York, New York 10022

Printed in the U.S.A.

BEFORE YOU BEGIN:

The materials that you'll need are --

NUMBER 2 PENCIL
ERASER
DRAWING PAPER
BLACK FELT-TIP MARKER

Start your drawing by lightly sketching.
STEP 1. Don't be afraid to erase until
you are satisfied with the way your sketch
looks. This is the most important step as
you will draw all the others on top of this.

STEP 2. Add this step, lightly in pencil, to
the first step. Don't be afraid to draw
through other shapes or to erase.

STEP 3. Add lightly in pencil. Again, don't be
afraid to draw through or to erase lines or
shapes you are not satisfied with.

Now you are ready to complete your drawing.
STEP 4. Finish your drawing using your black
felt-tip marker. Add details and black areas.
Erase all pencil marks. You can keep your
drawing the way it is, in black and white, or
add color.

HAPPY DRAWING!

DIPLODOCUS

STEP 1:

STEP 2:

STEP 3:

STEP 4:

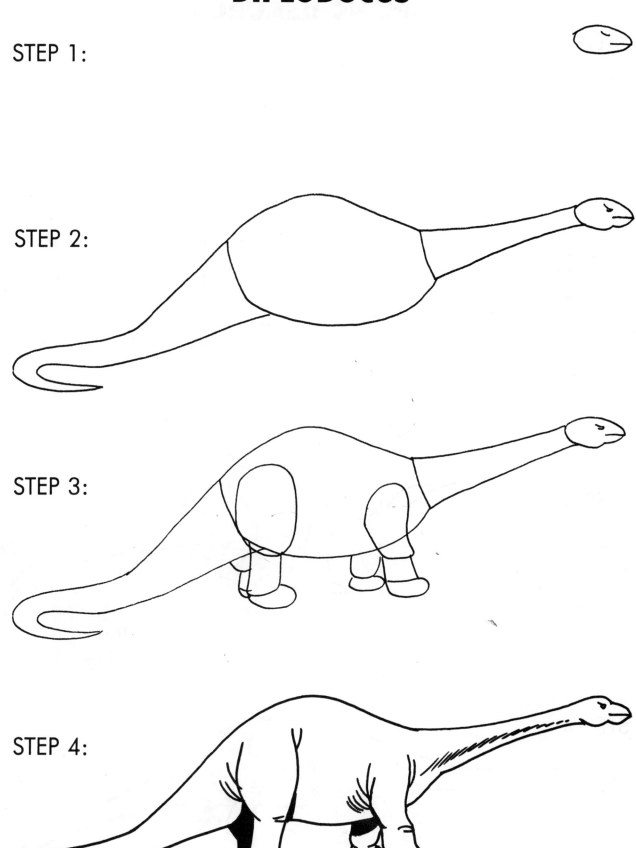

MAMENCHISAURUS

STEP 1:

STEP 2:

STEP 3:

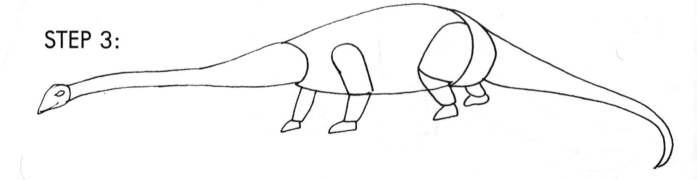

STEP 4:

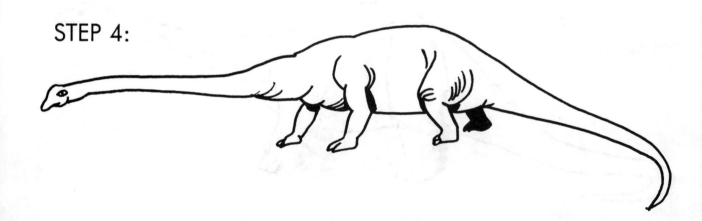

PLATEOSAURUS

STEP 1:

STEP 2: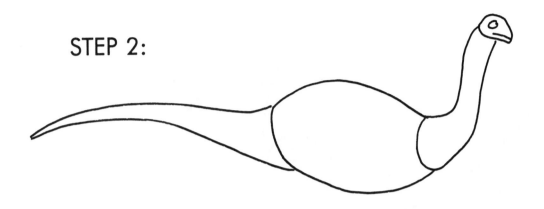

STEP 3: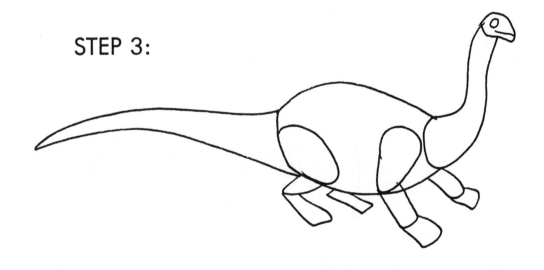

STEP 4: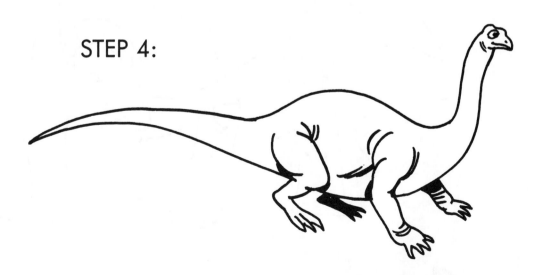

STEGOSAURUS

STEP 1:

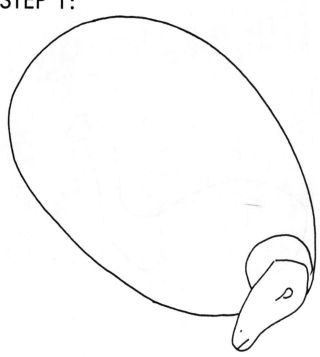

STEP 2:

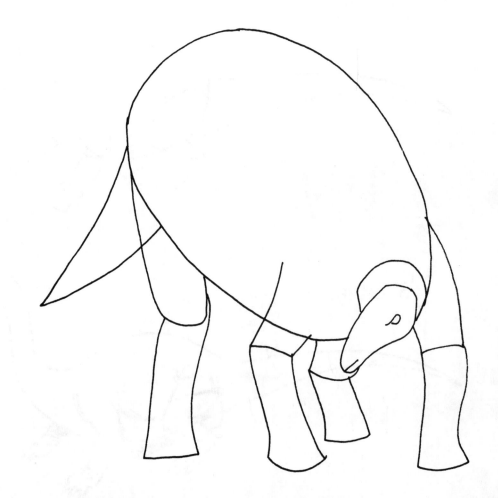

STEP 3:

STEP 4:

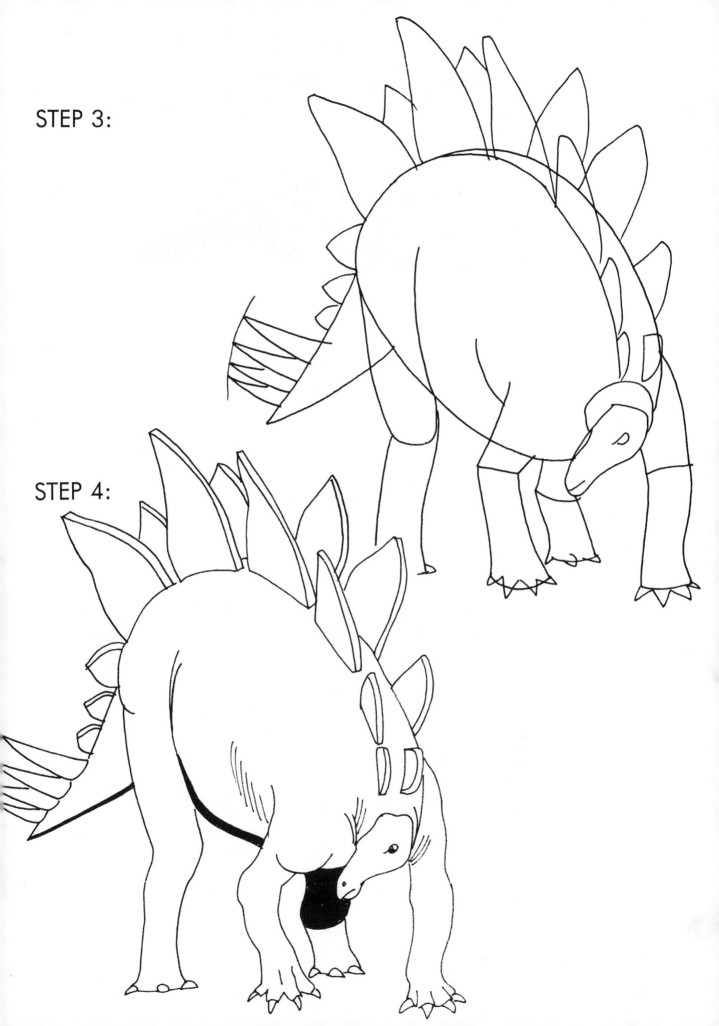

DROMICEIOMIMUS

STEP 1:

STEP 2:

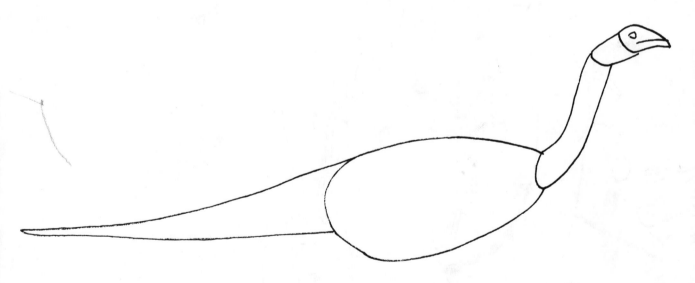

STEP 3:

STEP 4:

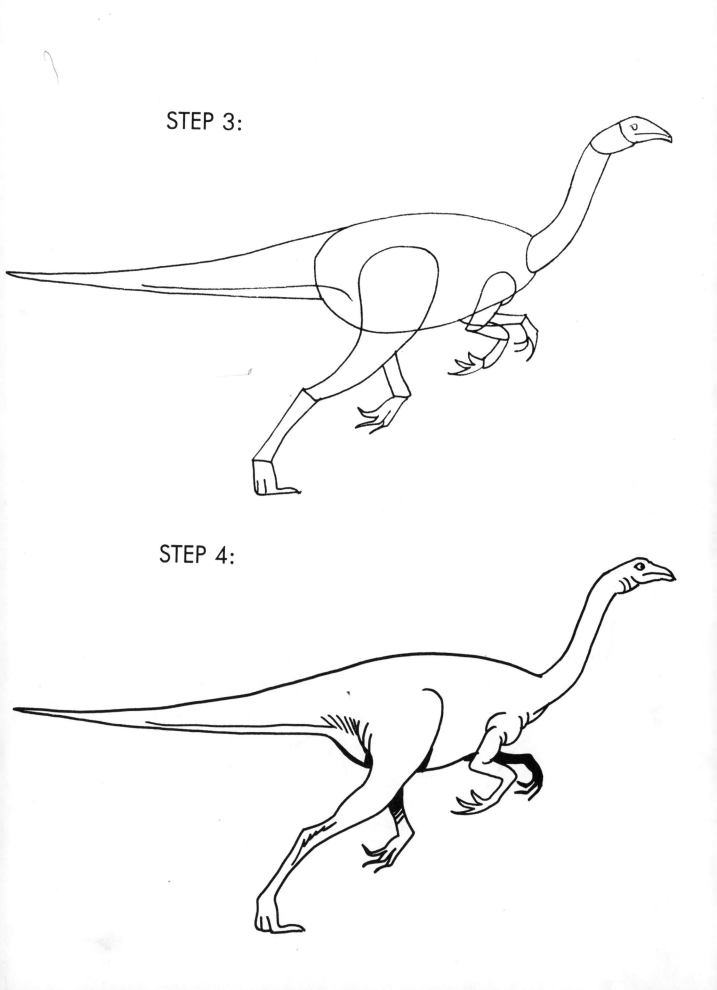

DILOPHOSAURUS

STEP 1: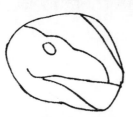

STEP 2:

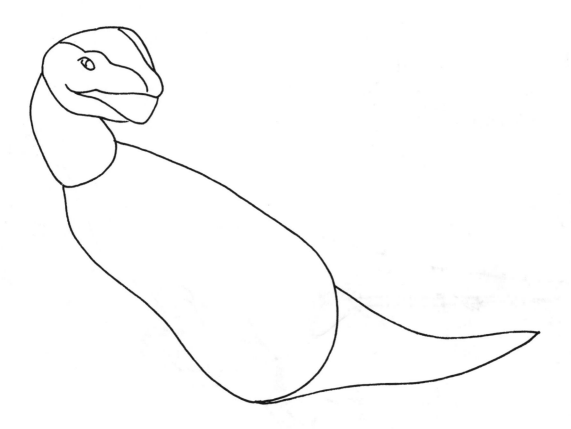

STEP 3:

STEP 4:

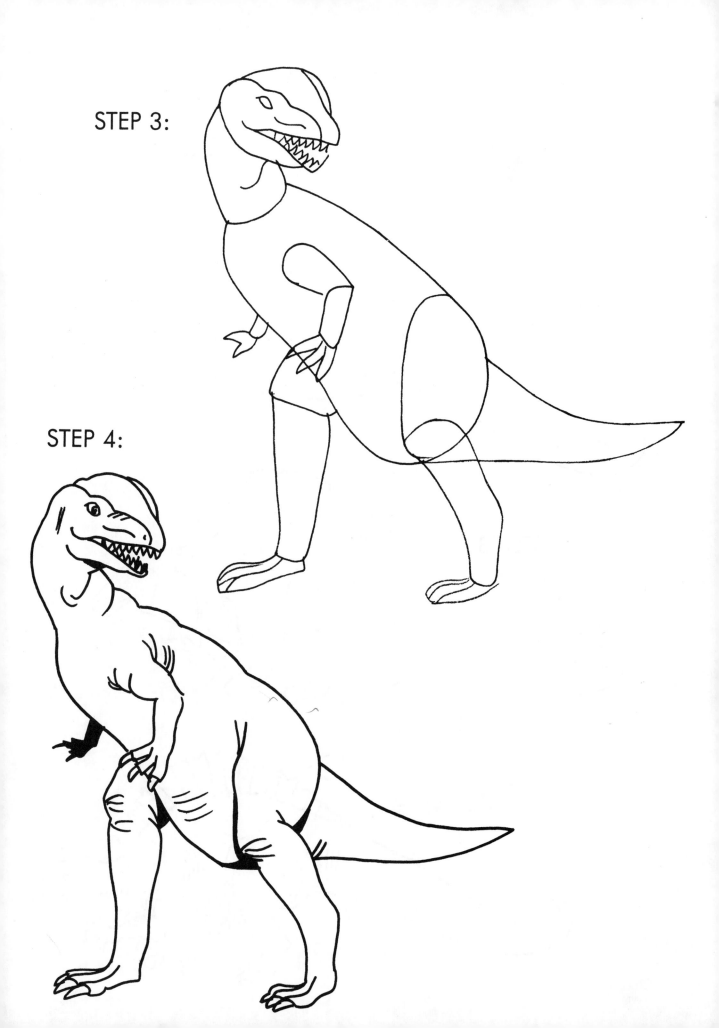

ALTISPINAX

STEP 1:

STEP 2:

STEP 3:

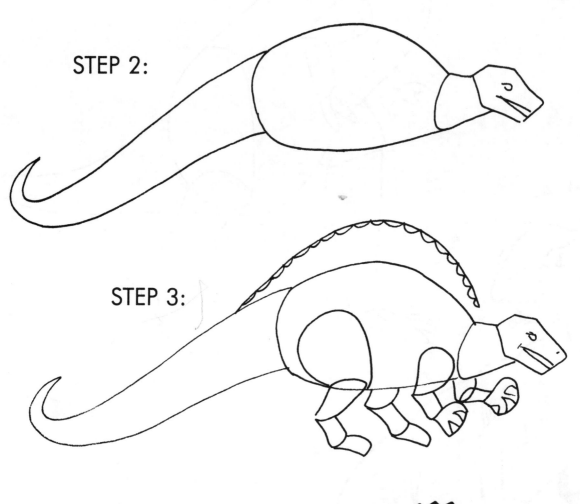

STEP 4:

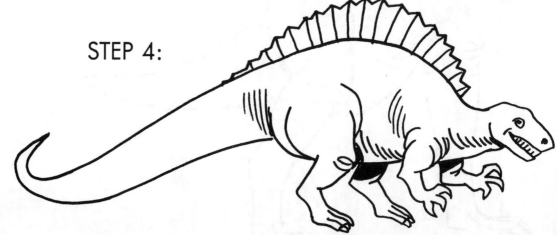

SCOLOSAURUS

STEP 1:

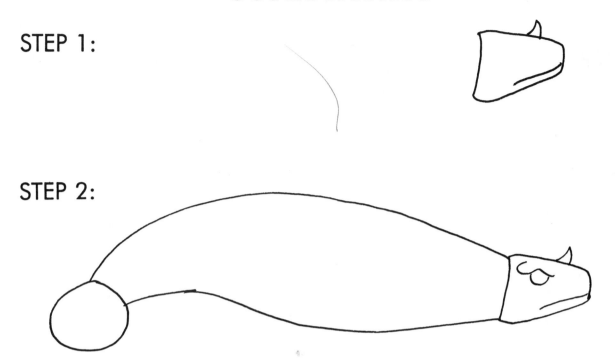

STEP 2:

STEP 3:

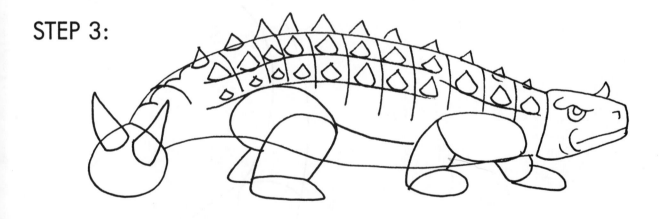

STEP 4:

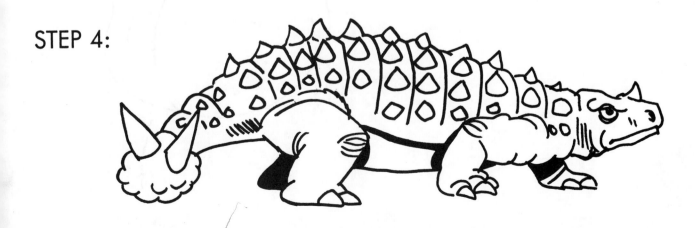

BRACHIOSAURUS

STEP 1:

STEP 2:

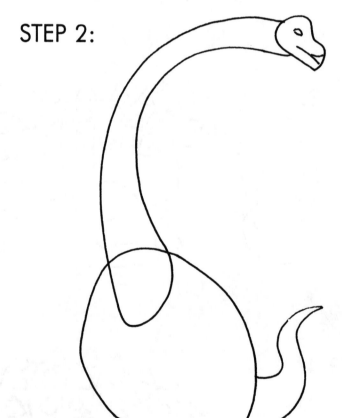

STEP 3:

STEP 4:

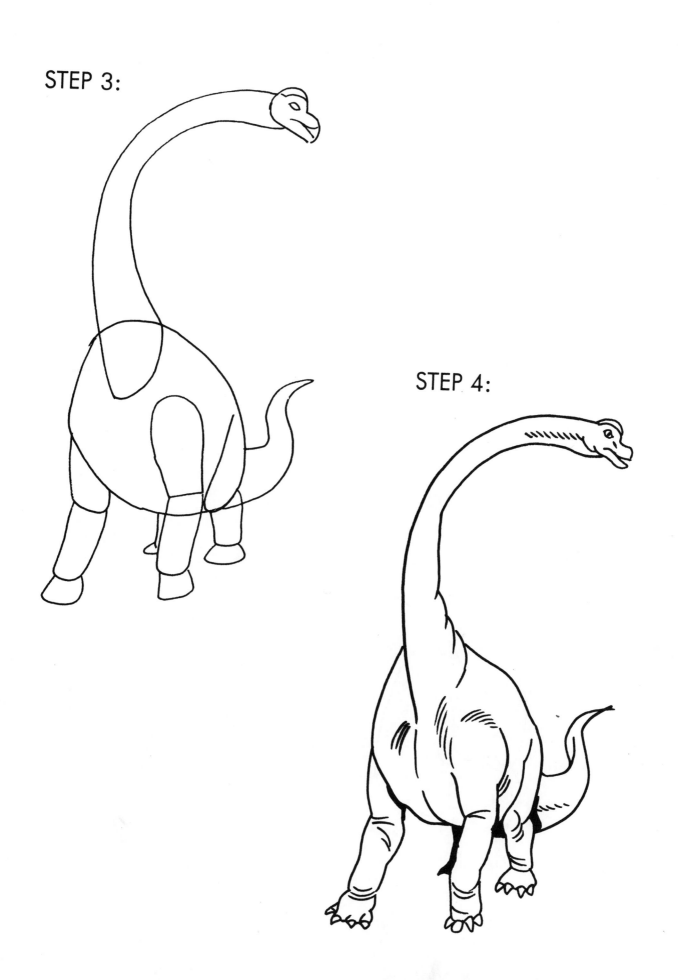

STYRACOSAURUS

STEP 1:

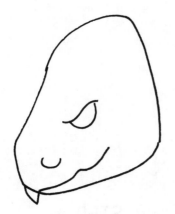

STEP 2:

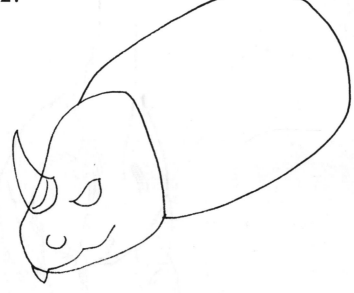

STEP 3:

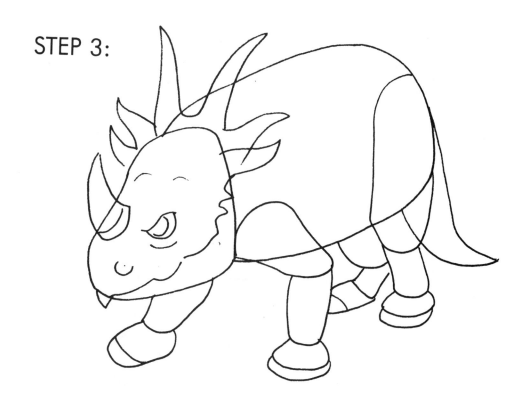

STEP 4:

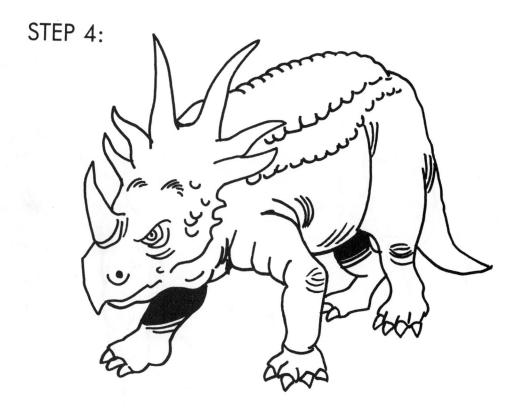

IGUANODON

STEP 1:

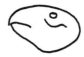

STEP 2:

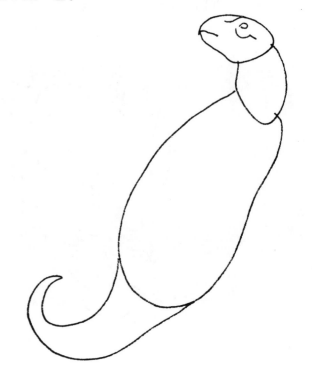

STEP 3:

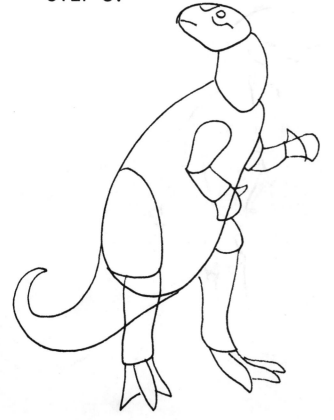

STEP 4:

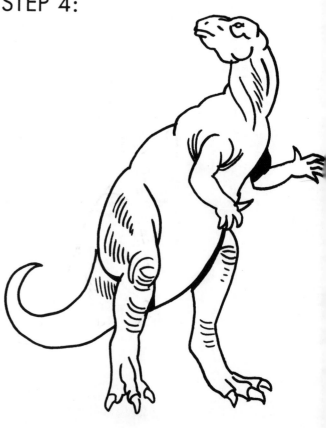

ALBERTOSAURUS

STEP 1:

STEP 2:

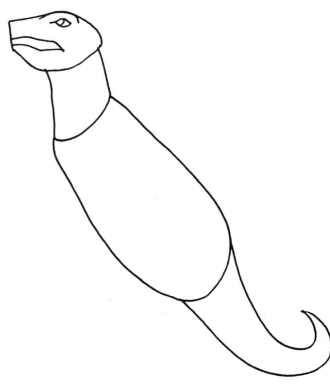

STEP 3:

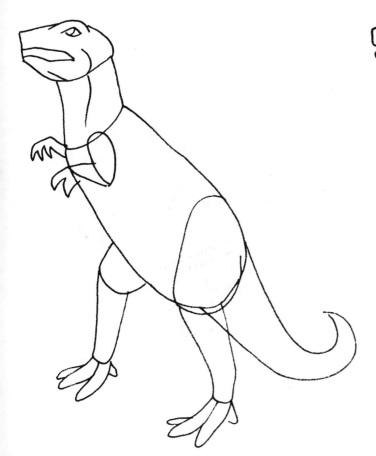

STEP 4:

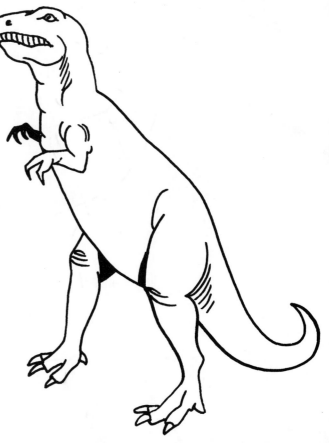

PODOKESAURUS

STEP 1:

STEP 2:

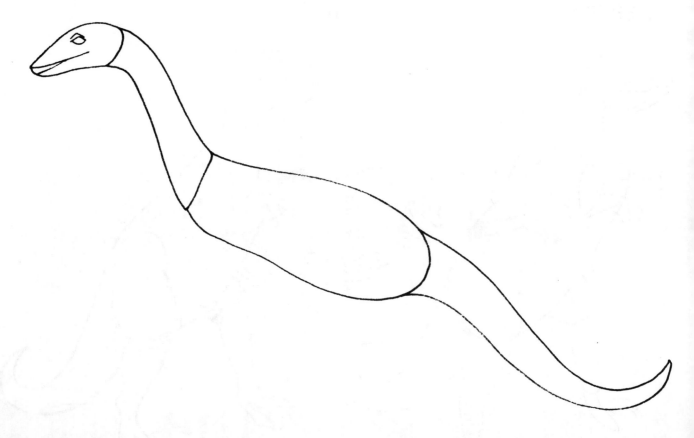

STEP 3:

STEP 4:

PARASAUROLOPHUS

STEP 1:

STEP 2:

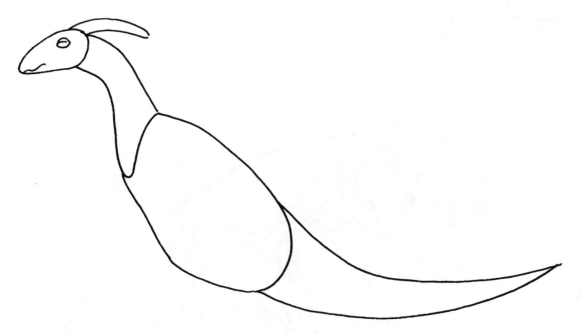

STEP 3:

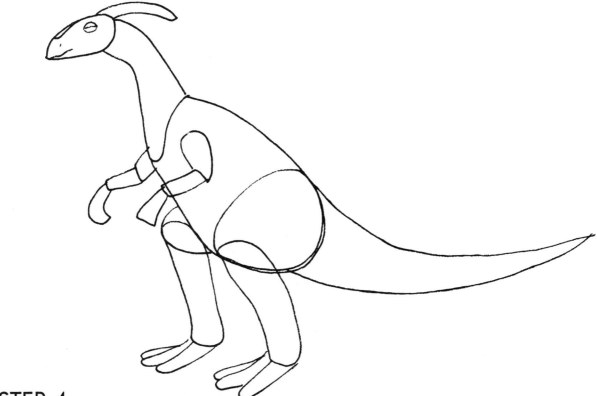

STEP 4:

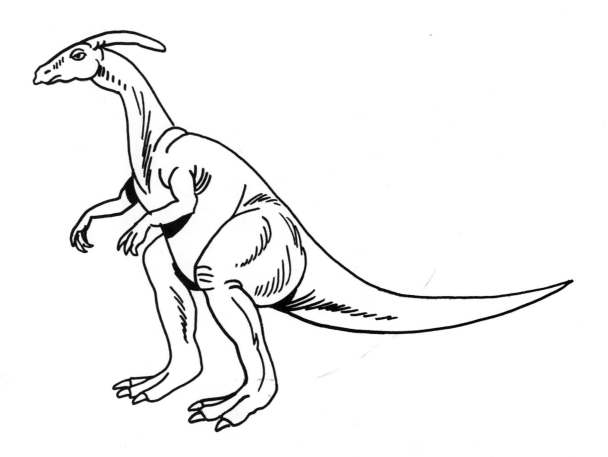

MEGALOSAURUS

STEP 1:

STEP 2:

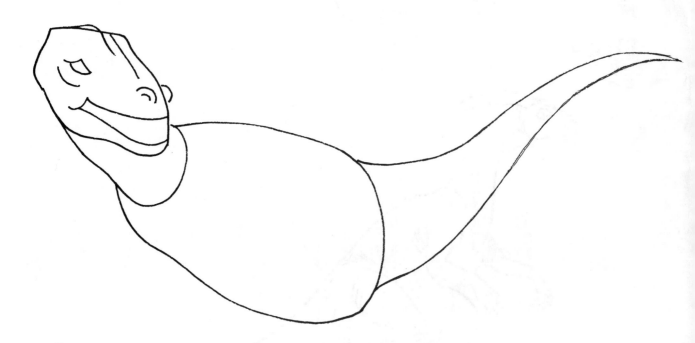

STEP 3:

STEP 4:

DEINONYCHUS

STEP 1:

STEP 2:

STEP 3:

STEP 4:

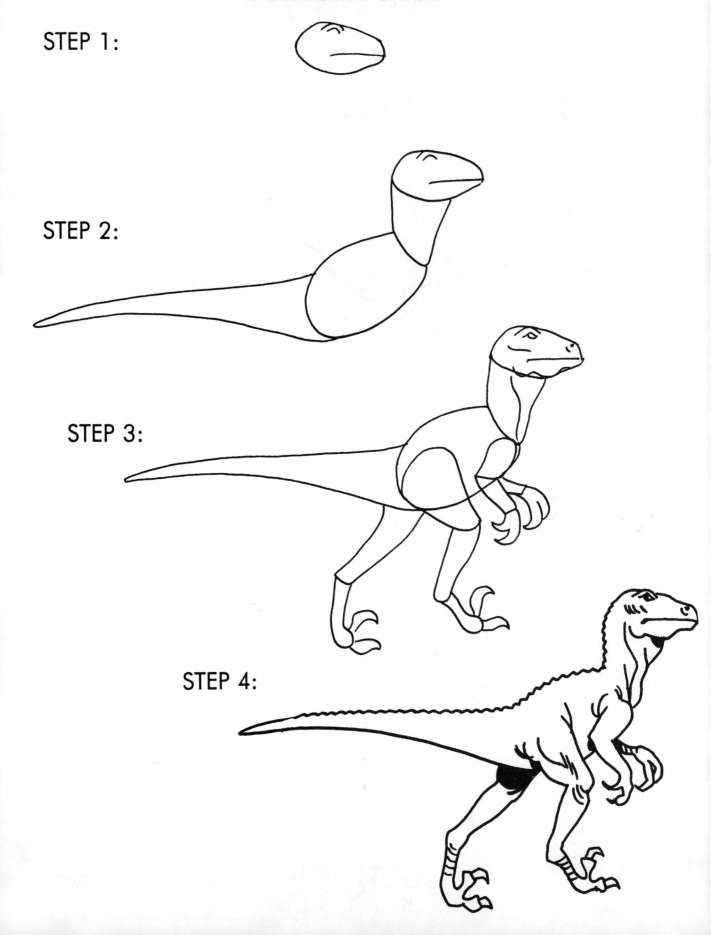

ALLOSAURUS

STEP 1:

STEP 2:

STEP 3:

STEP 4:

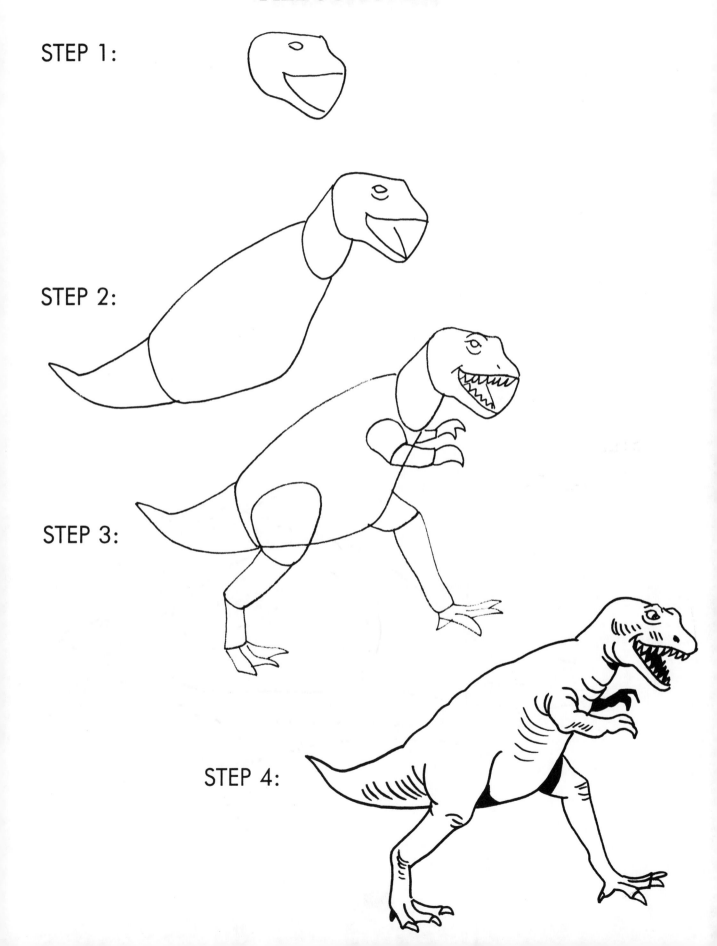

LEXOVISAURUS

STEP 1:

STEP 2:

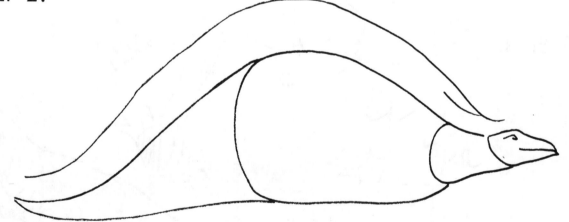

STEP 3:

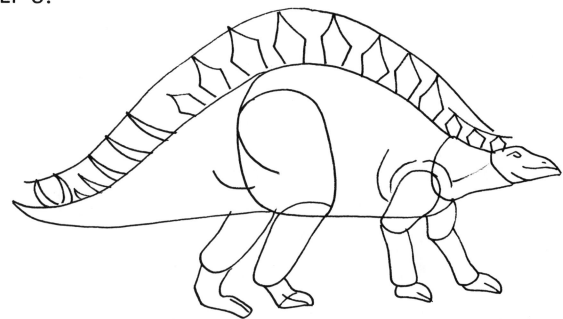

STEP 4:

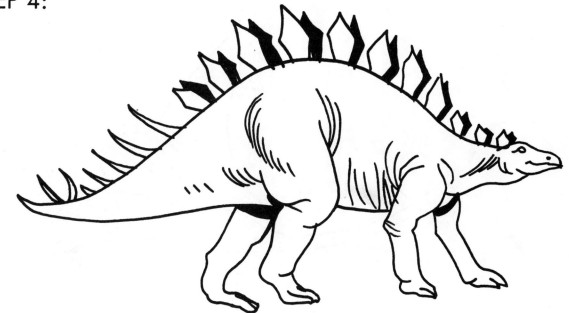

DIMORPHODON

STEP 1:

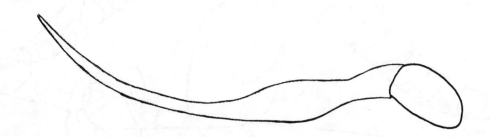

STEP 2:

STEP 3:

STEP 4:

TYRANNOSAURUS

STEP 1:

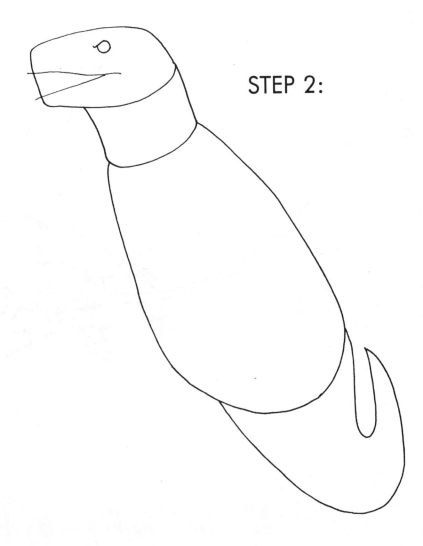

STEP 2:

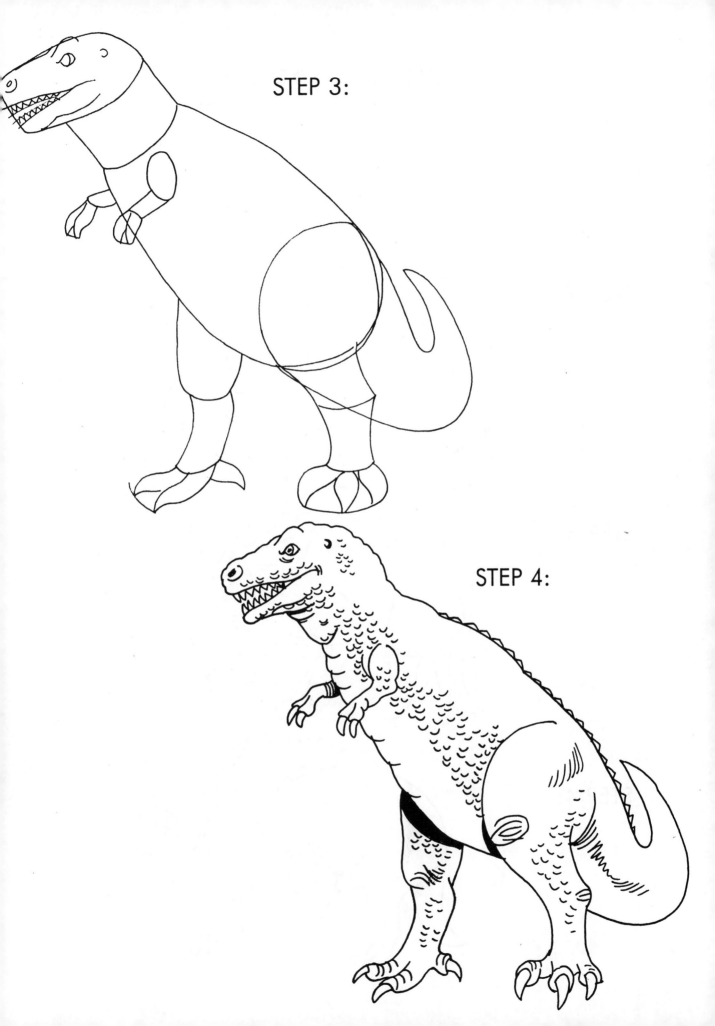

STEP 3:

STEP 4:

CHASMOSAURUS

STEP 1:

STEP 2:

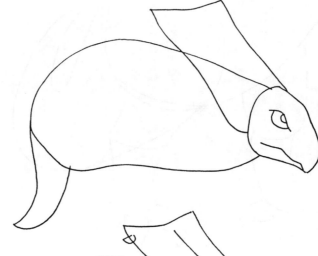

STEP 3:

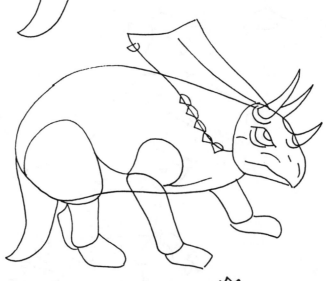

STEP 4:

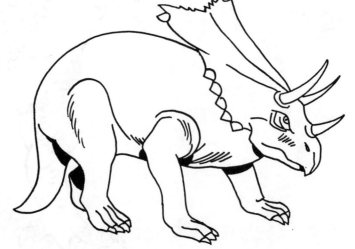

STENONYCHOSAURUS

STEP 1:

STEP 2:

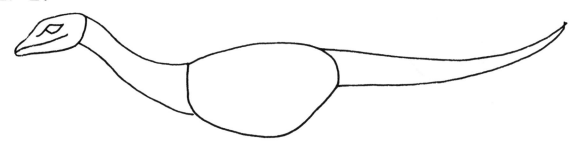

STEP 3:

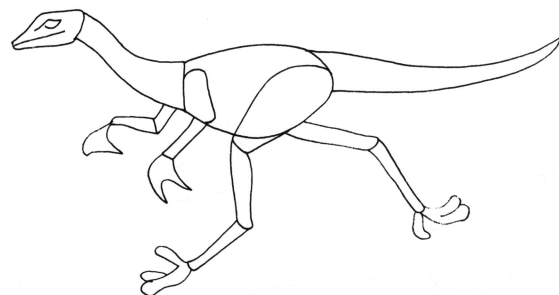

STEP 4:

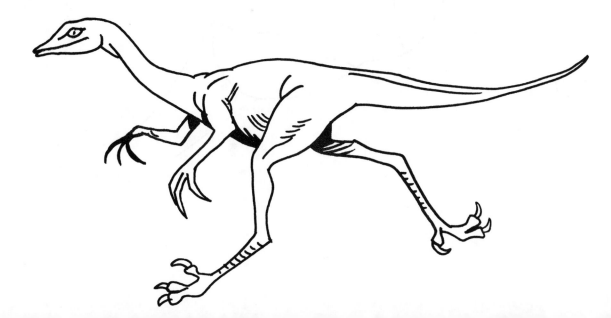

SPINOSAURUS

STEP 1:

STEP 2:

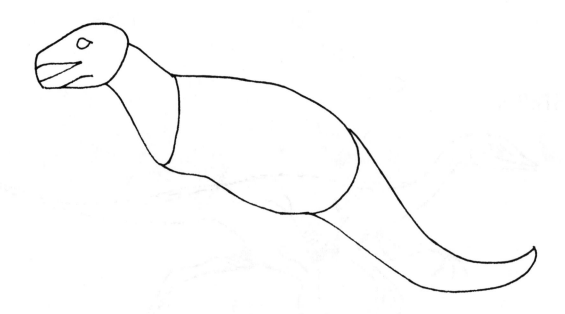

STEP 3:

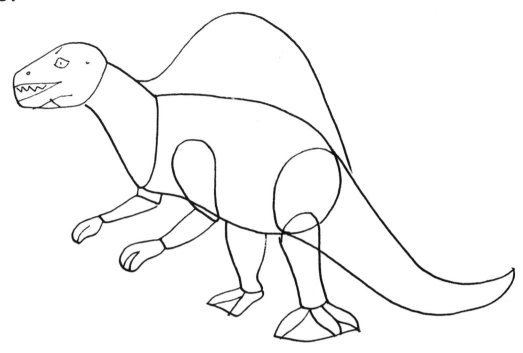

STEP 4:

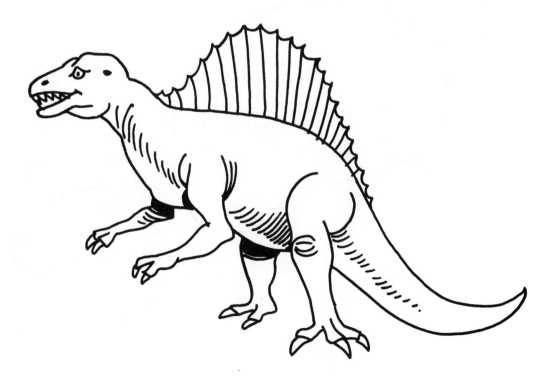

ANATOSAURUS

STEP 1:

STEP 2:

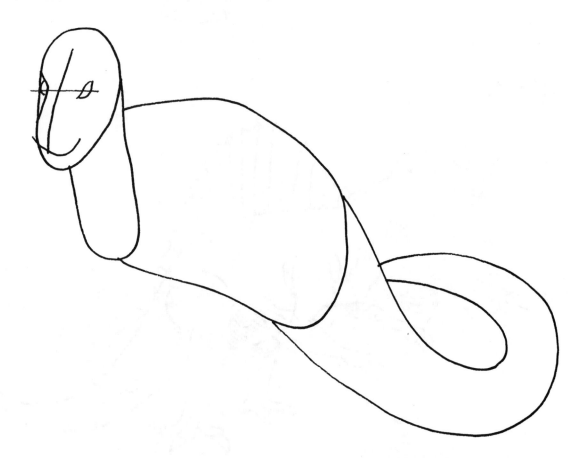

STEP 3:

STEP 4:

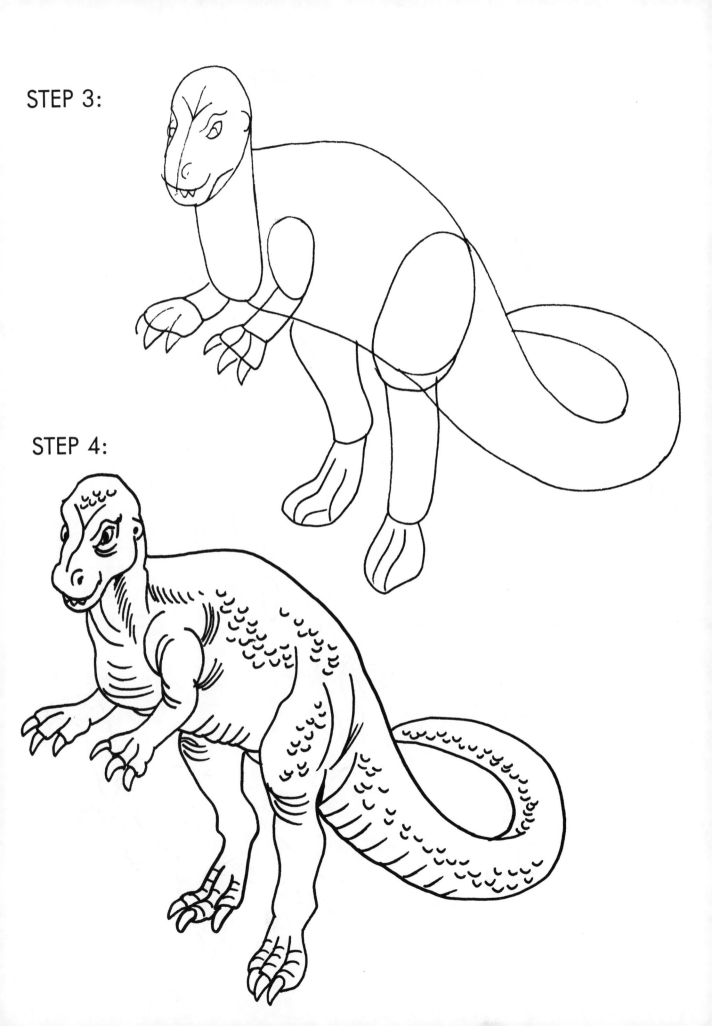

COMPSOGNATHUS

STEP 1:

STEP 2:

STEP 3:

STEP 4:

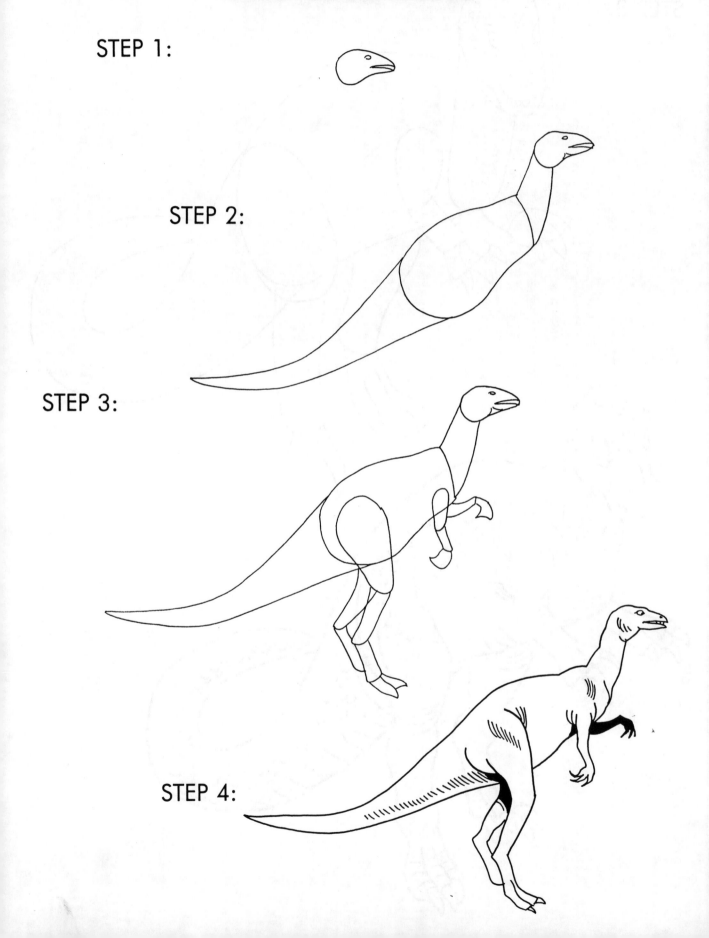

CENTROSAURUS

STEP 1:

STEP 2:

STEP 3:

STEP 4:

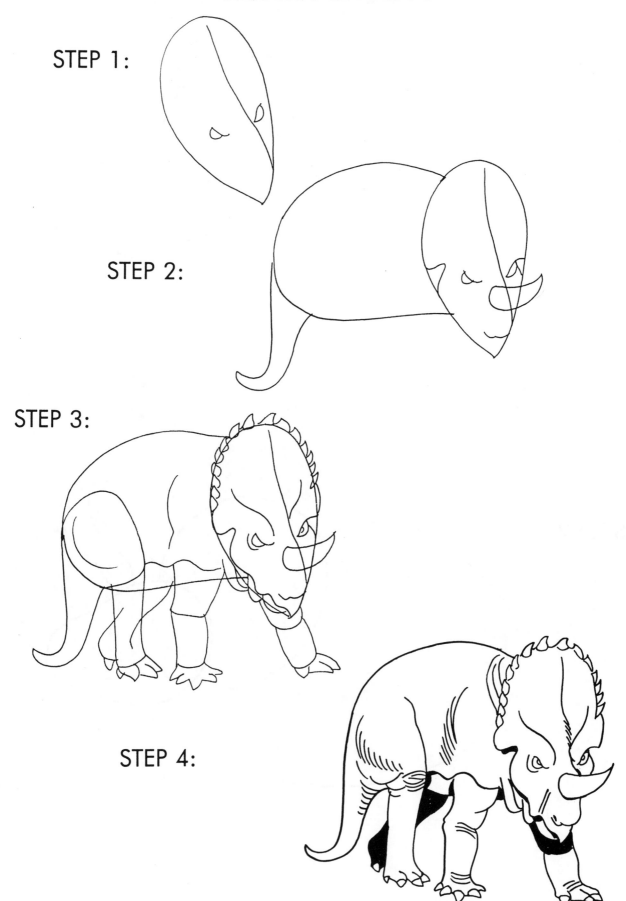

TRICERATOPS

STEP 1:

STEP 2:

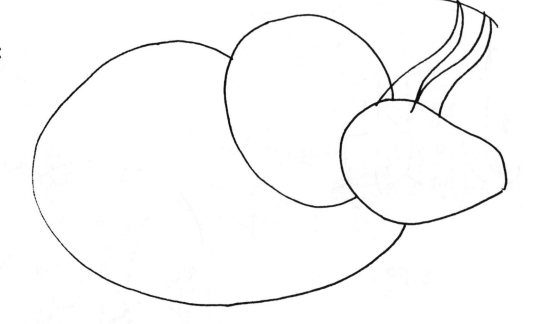

STEP 3:

STEP 4:

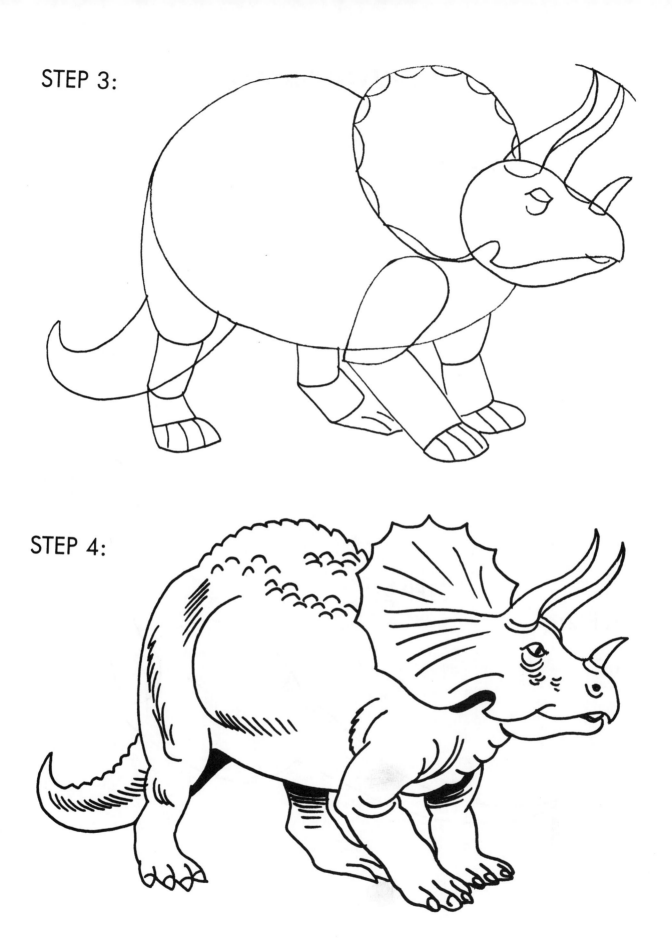

STRUTHIOMIMUS

STEP 1:

STEP 2:

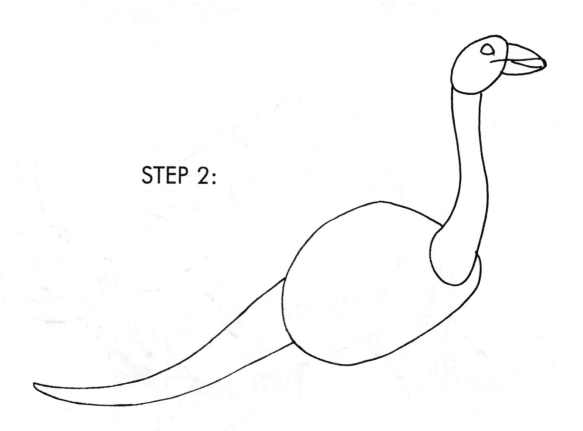

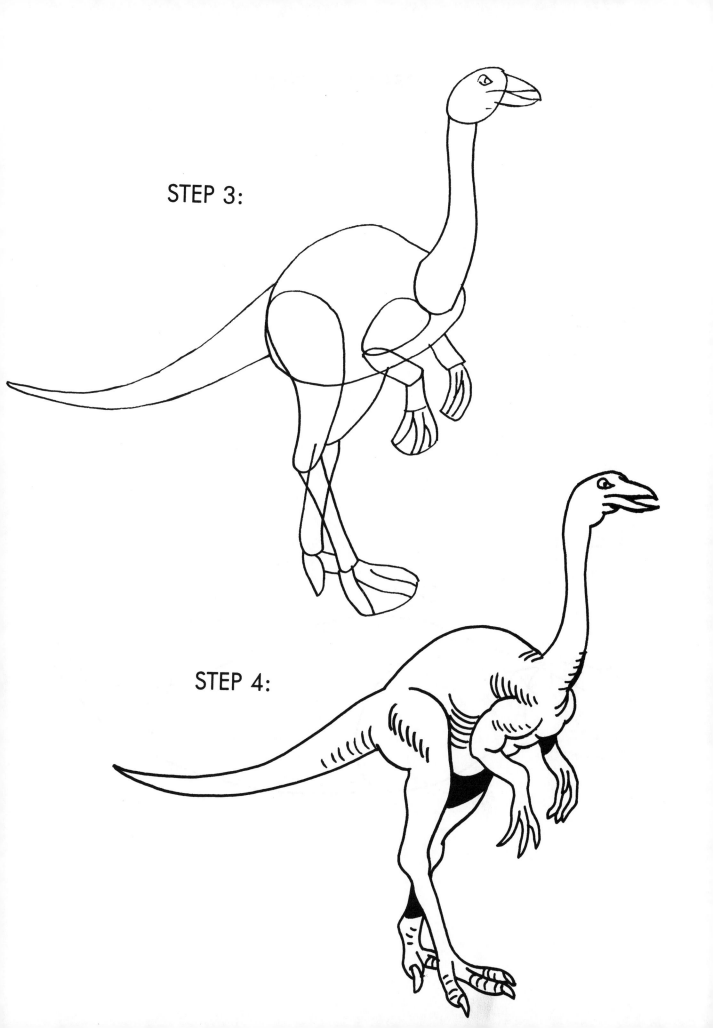

STEP 3:

STEP 4:

EUOPLOCEPHALUS

STEP 1:

STEP 2:

STEP 3:

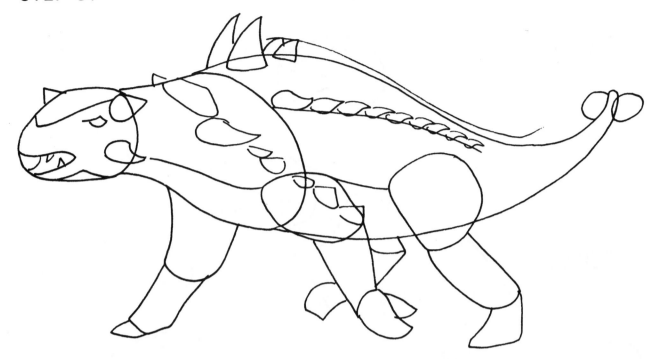

STEP 4:

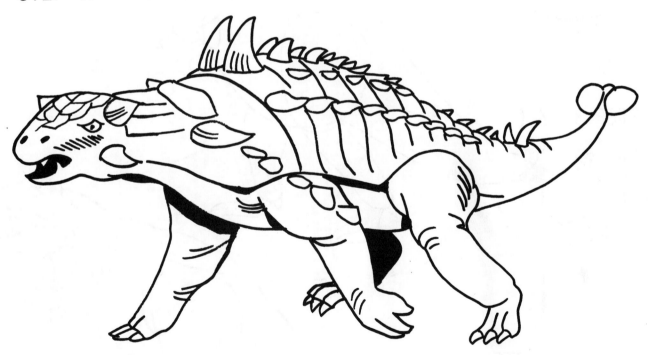

LABOCANIA

STEP 1:

STEP 2:

STEP 3:

STEP 4:

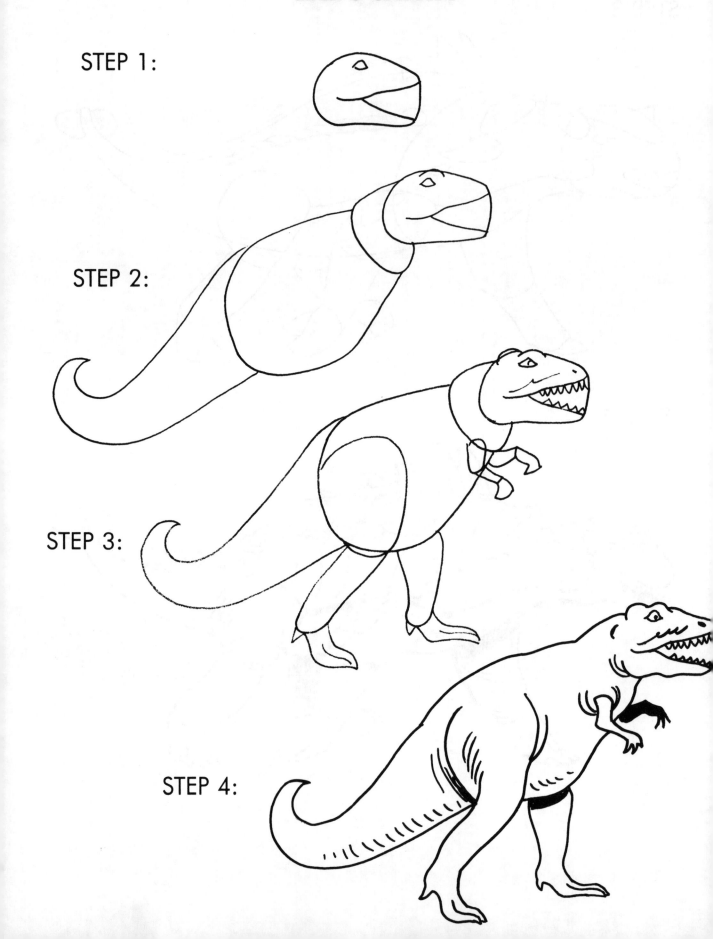

EDMONTOSAURUS

STEP 1:

STEP 2:

STEP 3:

STEP 4:

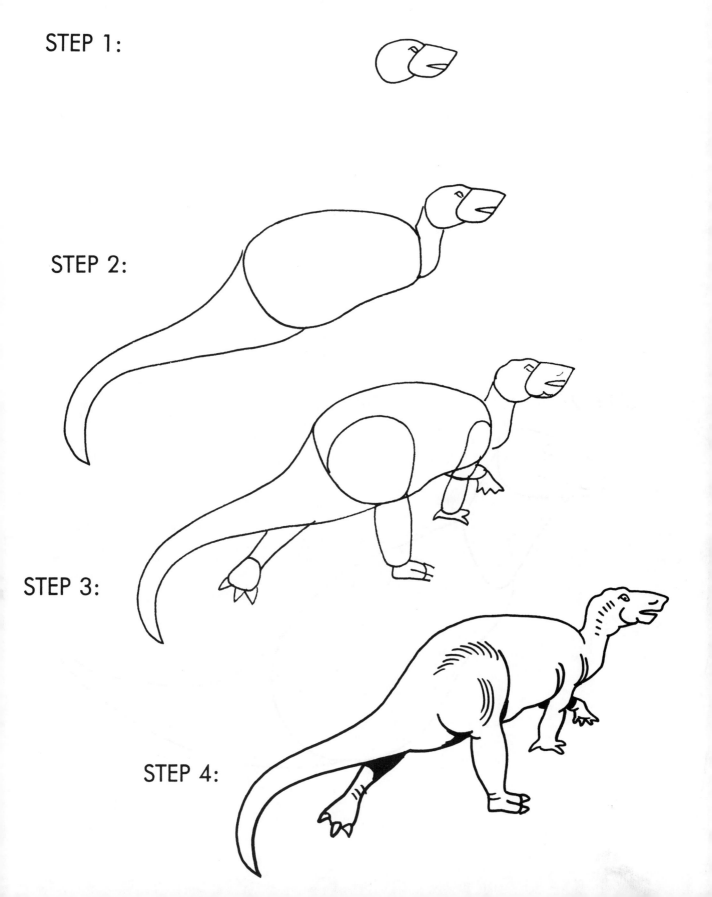

OURANOSAURUS

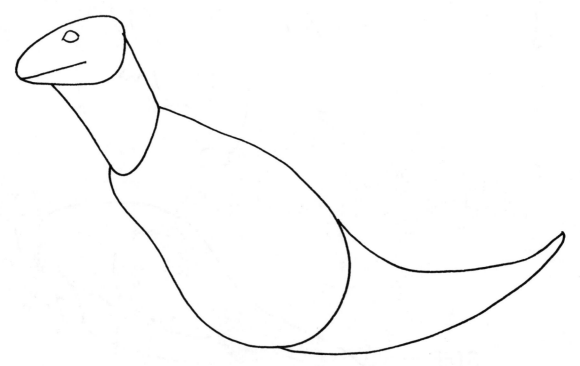

STEP 3:

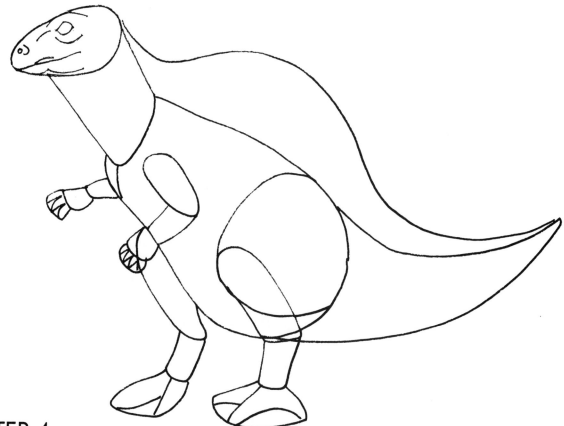

STEP 4:

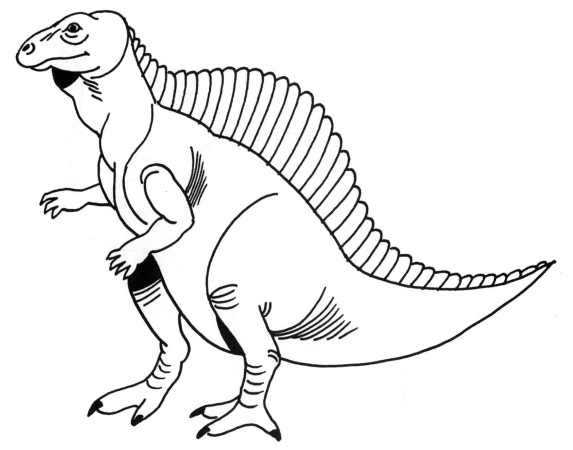

STAURIKOSAURUS

STEP 1:

STEP 2:

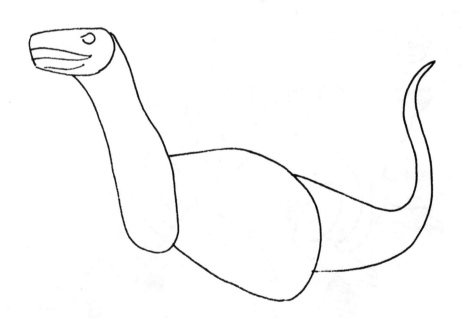

STEP 3:

STEP 4:

INGENIA

STEP 1:

STEP 2:

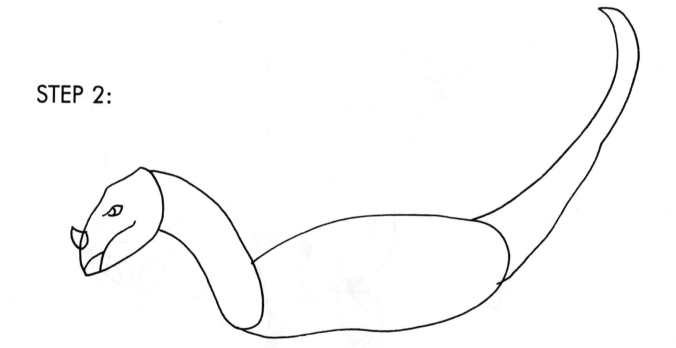

STEP 3:

STEP 4:

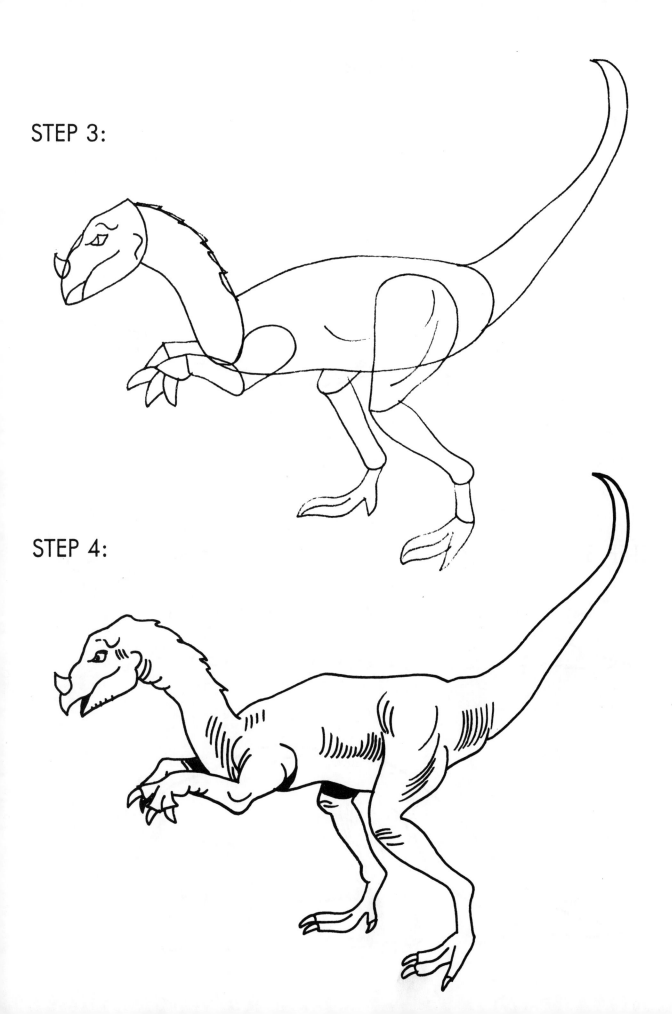

BAGACERATOPS

STEP 1:

STEP 2:

STEP 3:

STEP 4:

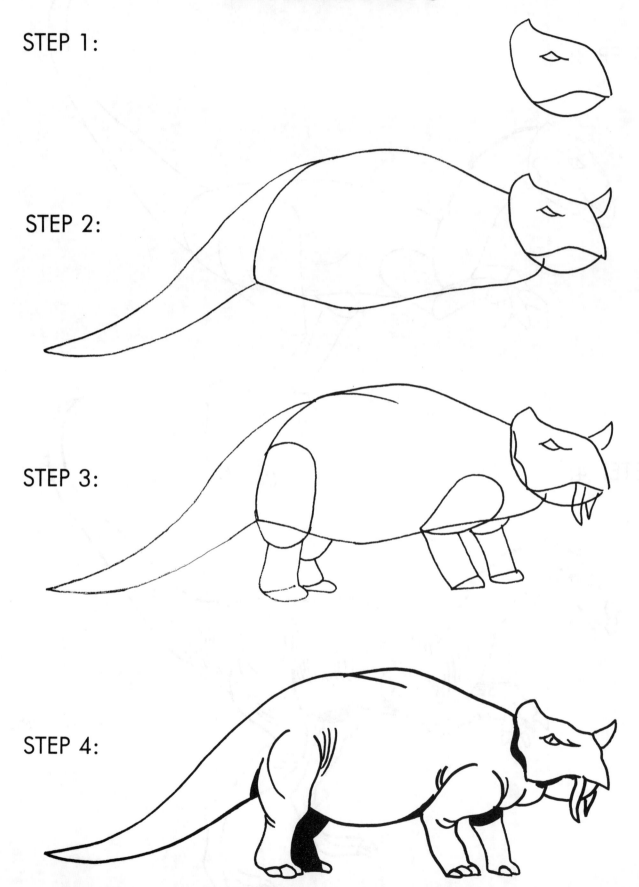

GERANOSAURUS

STEP 1:

STEP 2:

STEP 3:

STEP 4:

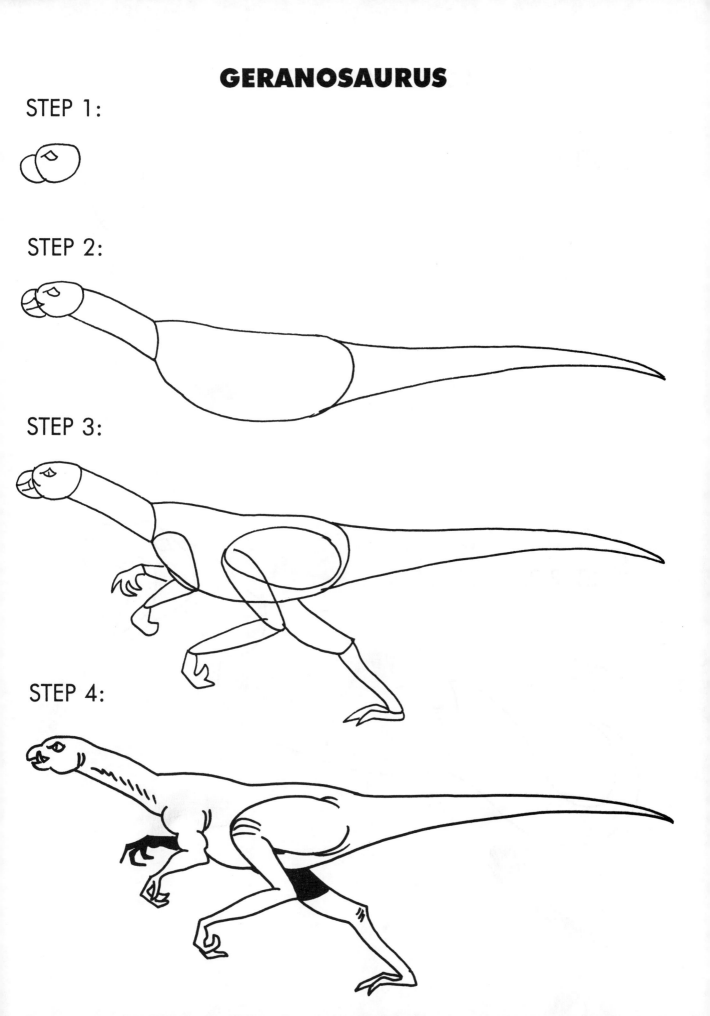

HERRERASAURUS

STEP 1:

STEP 2:

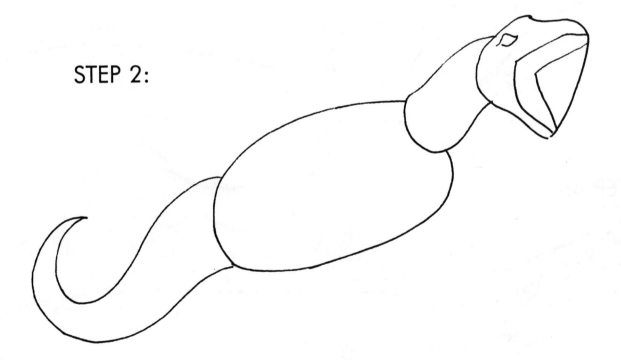

STEP 3:

STEP 4:

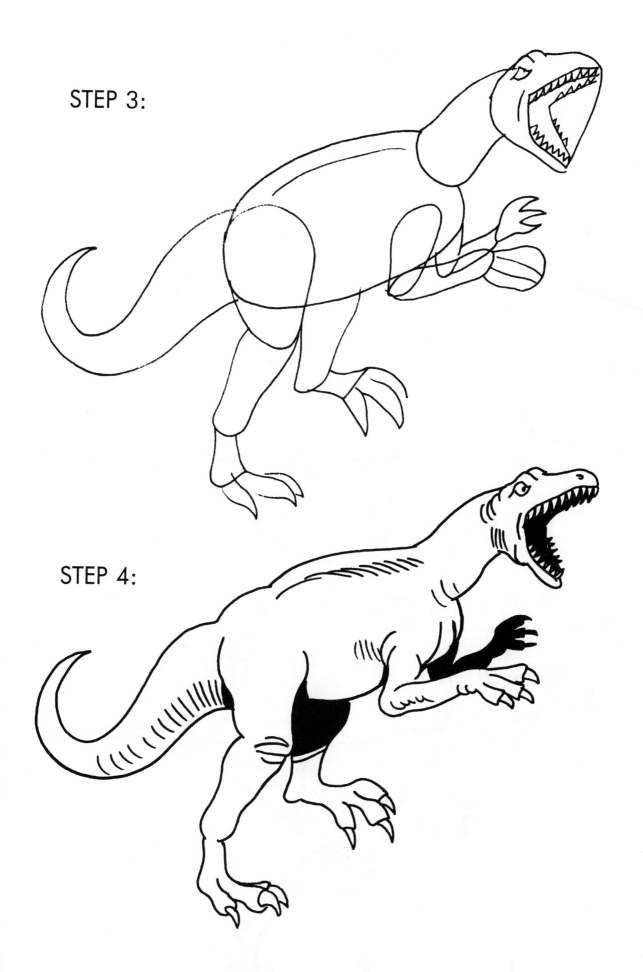

LESOTHOSAURUS

STEP 1:

STEP 2:

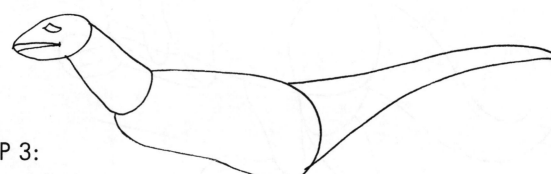

STEP 3:

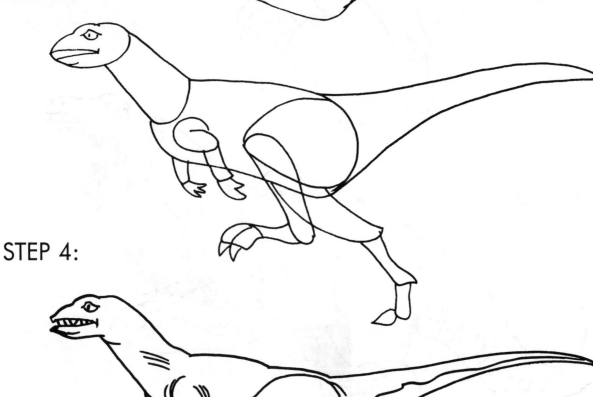

STEP 4:

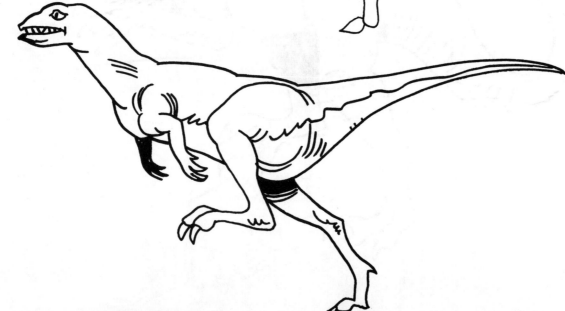

HADROSAURUS

STEP 1:

STEP 2:

STEP 3:

STEP 4:

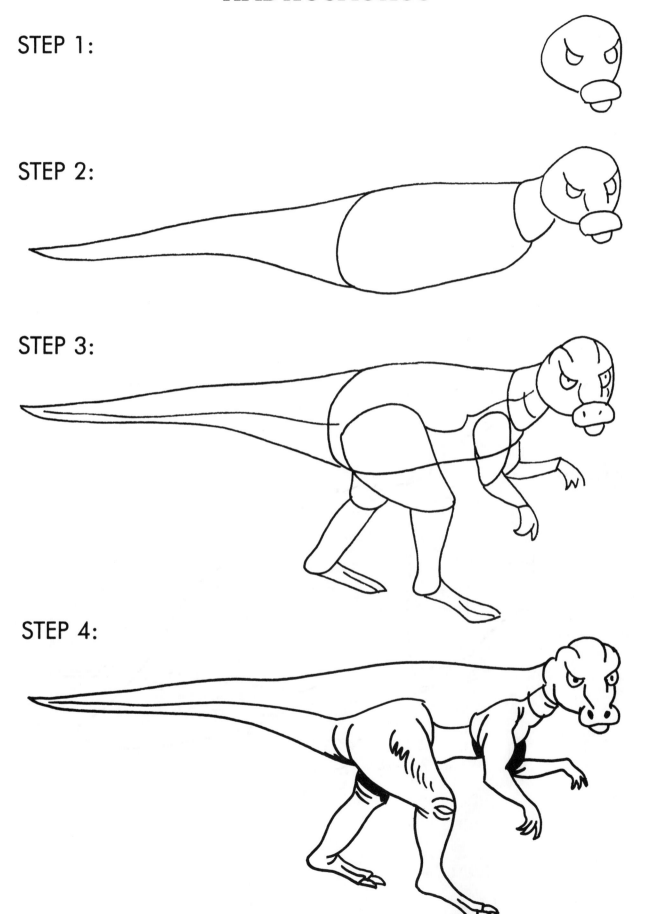

KRITOSAURUS

STEP 1:

STEP 2:

STEP 3:

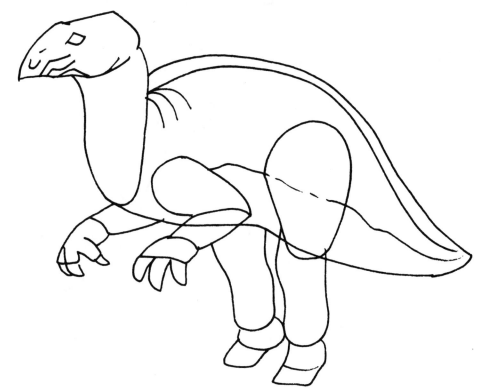

STEP 4:

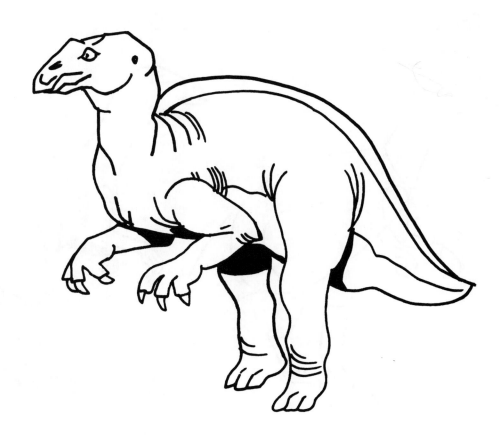

ANATOSAURUS

STEP 1:

STEP 2:

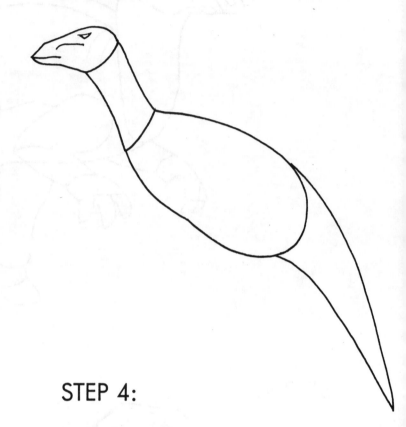

STEP 3:

STEP 4:

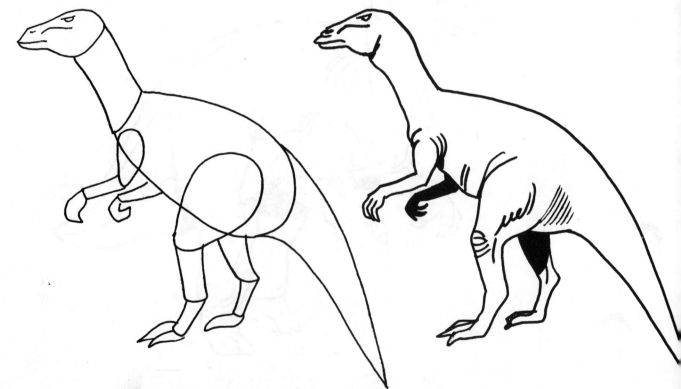